MASQUERADE

THE MASK AS ART

MASQU

FOREWORD BY
JOSEPH CAMPBELL

PREFACE BY
MAURICE TUCHMAN

CHRONICLE BOOKS
SAN FRANCISCO

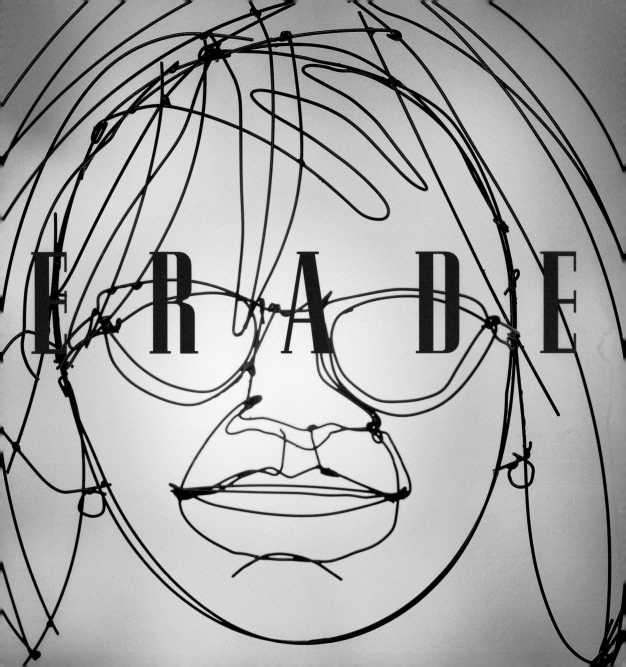

Many thanks to Sandra Kline
for her invaluable contributions
throughout this project.

Printed in Hong Kong.

Designed by Robin Weiss.

Library of Congress Cataloging-in-Publication Data

Masquerade / foreword by Joseph Cambell : preface by Maurice Tuchman.
 p. cm.
 Curated by Maurice Tuchman.
 ISBN 0-8118-0445-3: $16.95
 1. Masks—Catalogs. 2. Art, Modern—20th century—Catalogs.
3. Los Angeles County Museum of Art. 1. Tuchman, Maurice.
N8222.M39M37 1993
709´.04´907479494—dc20

Distributed in Canada by Raincoast Books
112 East Third Avenue
Vancouver, B. C. V5T 1C8

10 9 8 7 6 5 4 3 2 1

Chronicle Books
275 Fifth Street
San Francisco, CA 94103

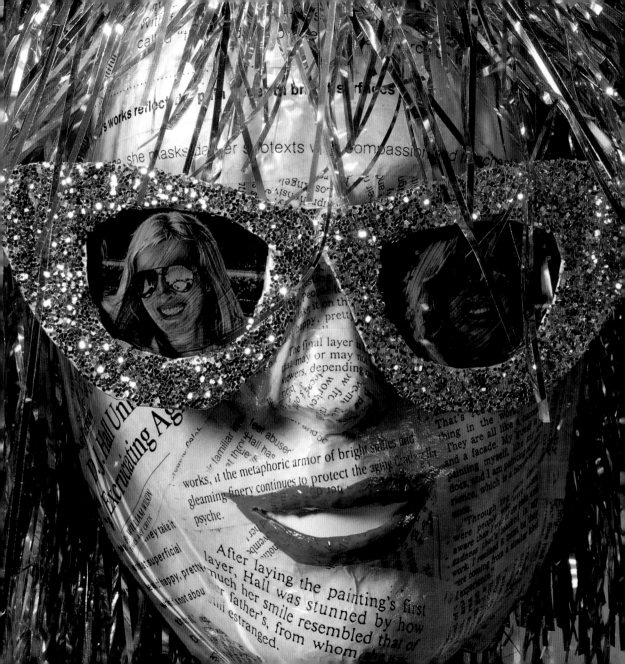

FOREWORD

BY JOSEPH CAMPBELL
From *Masks of God: Primitive Mythology*

*T*he artist eye, as Thomas Mann has said, has a mythical slant upon life; therefore, the mythological realm—the world of the gods and demons, the carnival of their masks and the curious game of "as if" in which the festival of the lived myth abrogates all the laws of time, letting the dead swim back to life, and the "once upon a time" become the very present—we must approach and first regard with the artist's eye. For, indeed, in the primitive world, where most of the clues to the origin of mythology must be sought, the gods and demons are not conceived in the way of hard and fast, positive realities. A god can be simultaneously in two or more places—like a melody, or like the form of a traditional mask. And wherever he comes, the impact of his presence is the same: it is not reduced through multiplication. Moreover, the mask in a primitive festival is revered and experienced as a veritable apparition of the mythical being that it represents—even though everyone knows that a man made the mask and that a man is wearing it. The one wearing it, furthermore, is identified with the god during the time of the ritual of which the mask is a part. He does not merely represent the god; he *is* the god.

The literal fact that the apparition is composed of A, a mask, B, its reference to a mythical being, and C, a man, is dismissed from the mind, and the presentation is allowed to work without correction upon the sentiments of both the beholder and the actor. In other words, there has been a shift of view from the logic of the normal secular sphere, where things are understood to be distinct from one another, to a theatrical or play sphere, where they are accepted for what they are *experienced* as being and the logic is that of "make believe"—"as if."

PREFACE

BY MAURICE TUCHMAN
Senior Curator, Twentieth-Century Art
Los Angeles County Museum of Art

*T*he *Masquerade* project at the Los Angeles County Museum of Art came about in an unusual way. In anticipation of the October 1992 opening of *Parallel Visions: Modern Artists and Outsider Art*, plans were made to celebrate with a Halloween Outsiders Ball. The exhibition was coorganized by Carol S. Eliel, Associate Curator of Twentieth-Century Art, and myself; the Modern and Contemporary Art Council, which is the support group of the museum's twentieth-century art department, planned the ball. In preliminary discussions with council officers about the event, it struck me that a number of prominent painters and sculptors might create unique masks for us to sell that night at auction.

I tested the waters for this project by writing, in March 1992, to about eighty artists in the United States and Europe. Despite the continual entreaties to artists by charitable and political institutions for donated works, the response to my letters was remarkable. Many artists actually called or wrote to thank me for inviting them to participate. As the masks started to arrive— Roger Brown's, one of the first, was painted on the outside of a manila envelope and simply mailed from Chicago as a first-class letter—it became apparent that a nerve had been struck in the contemporary art community.

Throughout the summer masks cascaded into our offices. Such celebrated artists as Gordon Onslow-Ford, Robert Graham, Larry Rivers, and Tom Wesselmann enjoyed the "assignment" so much that they were inspired to make more than one. Many, including Vito Acconci, Karel Appel, John Chamberlain, Jess, Michael McMillen, Lee Mullican, Richard Pousette-Dart, Martin Puryear, and Italo Scanga, clearly descended into themselves to create challenging statements, masks that provoke fresh thoughts about their well-known art. In all of the masks

the sense arises that the artists probed personal questions of identity, contending with their deeper selves.

Parallel Visions itself evoked the common elements in the work of "outsiders," people who are compelled but rarely trained to make art and who often are unaware that what they are producing actually is art, and the work of "insiders," professional contemporary artists. These common elements are rivetingly expressed in the donated masks: the search for identity, concerns with personification and issues of authenticity and selfhood.

Surely the artists' probing accounts for the frequency of self-portraits in the *Masquerade* array, sometimes disguised but occasionally clearly manifest. Even when another person is portrayed, as in Vitaly Komar and Alexander Melamid's *Red Stalin*, an aspect of self-projection adds mystery to

the result. One can easily imagine that in the near future these and other artists may be asked to contend again with the genre.

To the artists, all of whom contributed their work with absolute generosity, granting the museum the total value of their creations toward acquisitions of contemporary art, I offer a deep salute of gratitude.

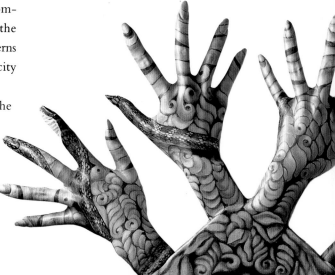

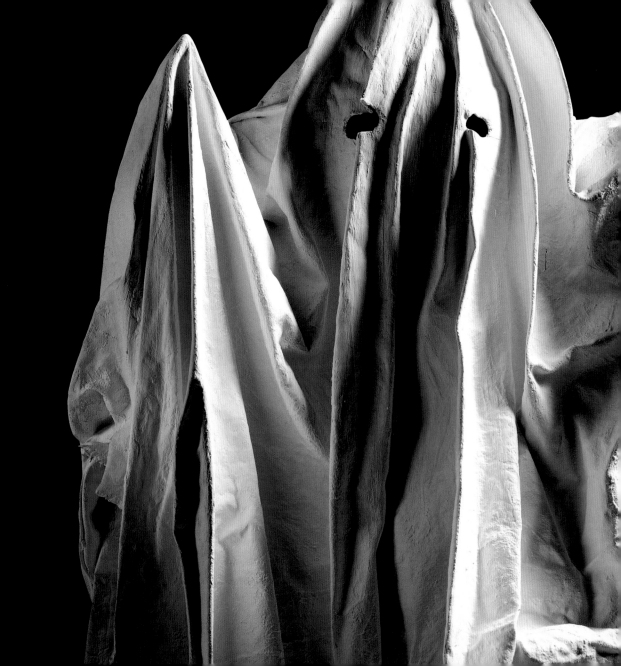

THE MASKS

Jess

Mask for All Souls, 1964/1992
paper collage and stuffed bird mounted
 on vintage photograph
24 x 19 x 6 inches
Collection of Marshall and Doris Redman

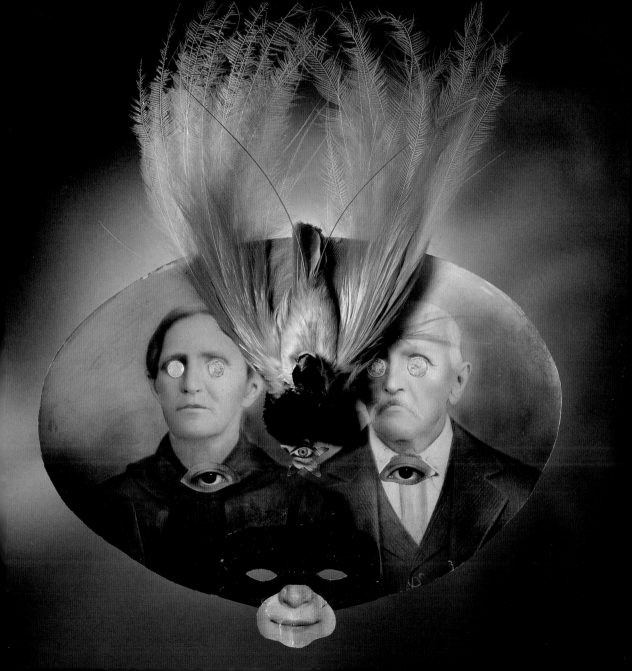

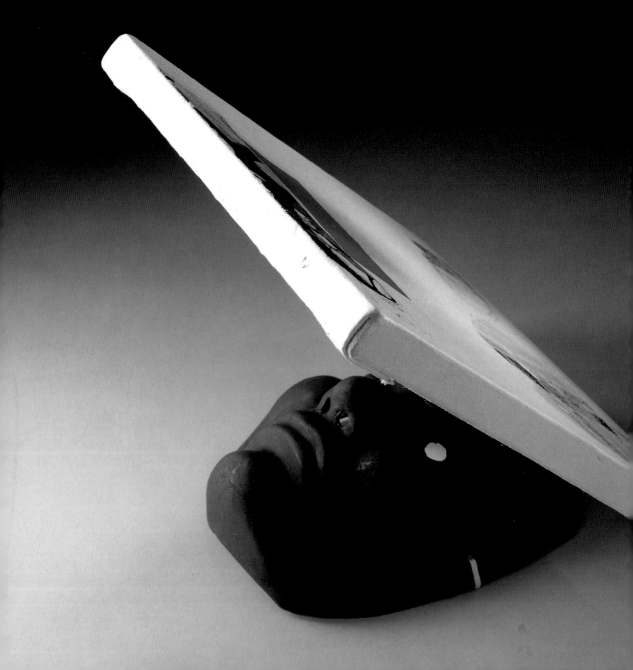

Peter Plagens ≺

Blind Man's Mask, 1992
signed, titled and dated on verso
painting and collage on canvas attached to mask
10 x 11 x 6 inches
Collection of Richard and Jan Baum

Kent Twitchell ≻

Ed Ruscha Mask, 1992
signed, titled and dated along recto edge
plaster with graphite
7¼ x 7 x 4 inches
Collection of Marshall and Patricia Geller

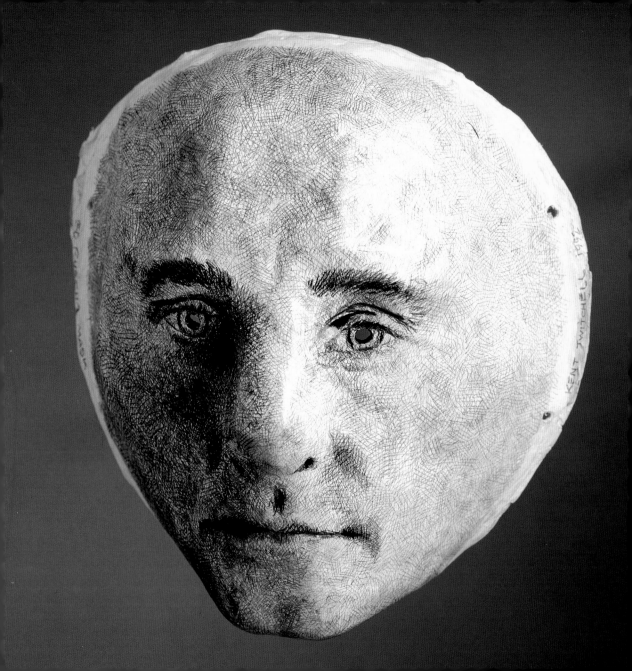

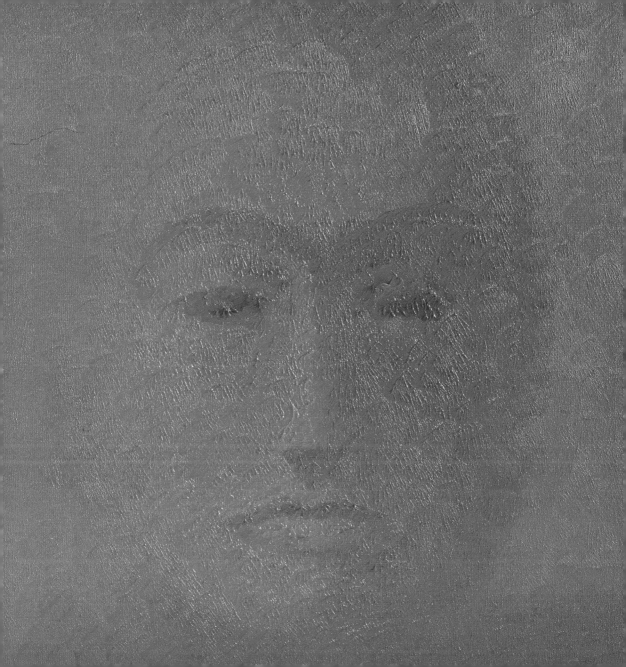

Martha Alf ◄

Mask Painting, 1992
oil on canvas
14 X 11 X ½ inches
Collection of Elinor and Rubin Turner

Sylvia Shap ➤

The Famous Maurice Mask, Reclaimed, 1992
signed "The Famous Maurice Mask! reclaimed
 by Sylvia Shap"
cut-out photograph with black construction
 paper and silver ink mounted on paperboard
 with accompanied press clippings highlighted
 by the artist
12½ X 12 inches
Collection of Larry Layne

THE FAMOUS MAURICE MASK!
RECLAIMED BY SYLVIA SHAP

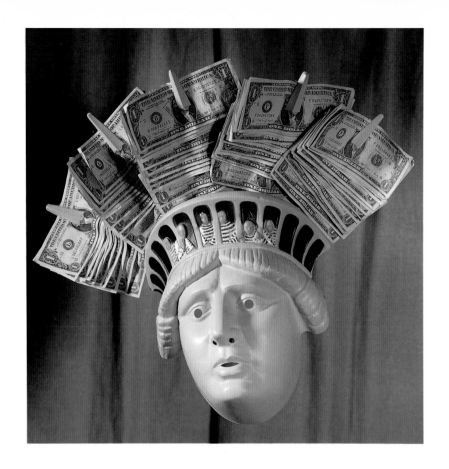

Miralda

A $ a Dance, 1992
signed and titled on verso
plastic "Liberty" mask with pencil and
 72 one dollar bills
approximately 17 x 16½ x 5½ inches
Collection of Jackie Applebaum

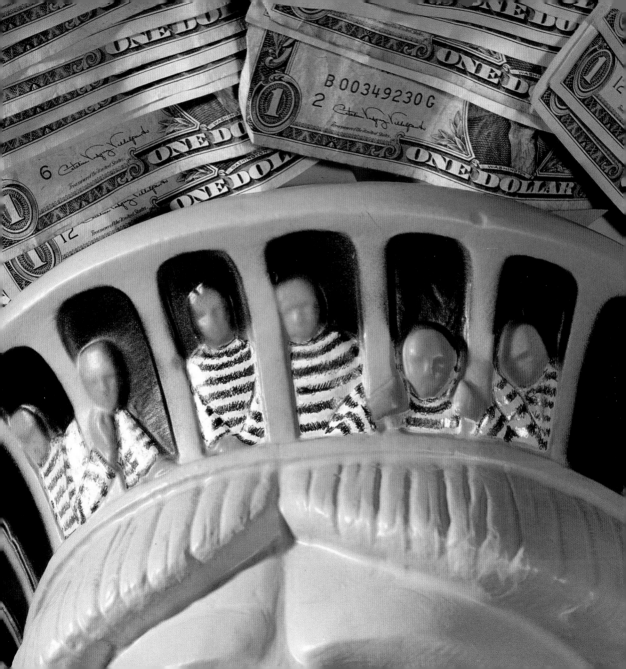

Richard Ross

Nick with Mask, 1992
signed
framed gelatin silver print
19¼ x 16 inches
Collection of Melodie Hollander

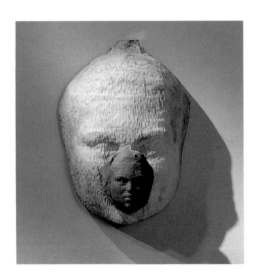

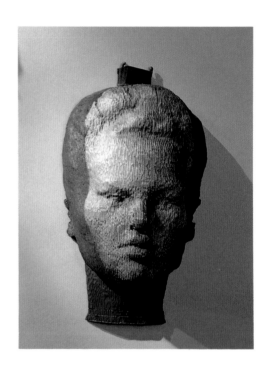

Robert Graham

Mask 1, 1992
unique cast bronze and green patina
6½ x 5 x 3⅓ inches
Collection of Ron and Nancy Lightstone

Robert Graham

Mask 2, 1992
unique cast bronze, black and gold patina
9½ x 5¼ x 4½ inches
Collection of Lee and Lawrence Ramer

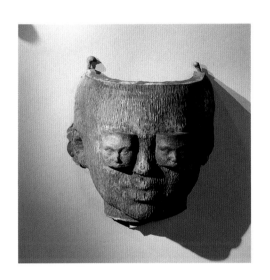

Robert Graham

Mask 3, 1992
unique cast bronze and blue patina
5½ x 5 x 3½ inches
Collection of Lee and Lawrence Ramer

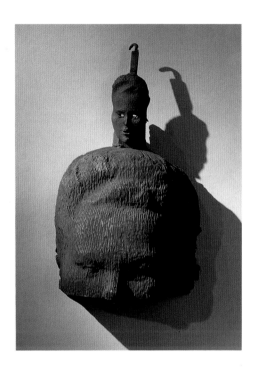

Robert Graham

Mask 4, 1992
unique cast bronze and black patina
8¾ x 5¼ x 3¼ inches
Collection of Bob and Rochelle Gluckstein

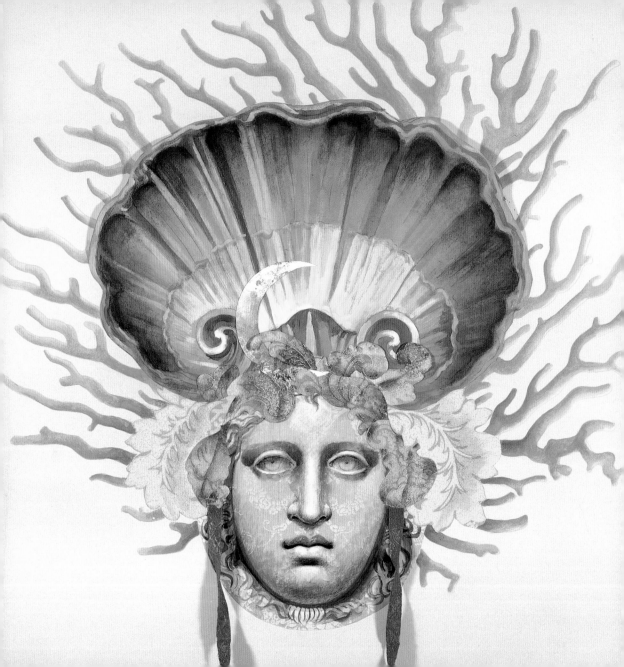

Carlo Maria Mariani

Project for a Mask, 1992
signed and dated lower right, titled lower left
pencil drawing and paper collage on paper
44 x 30½ inches
Collection of Lynne and Irwin Deutch

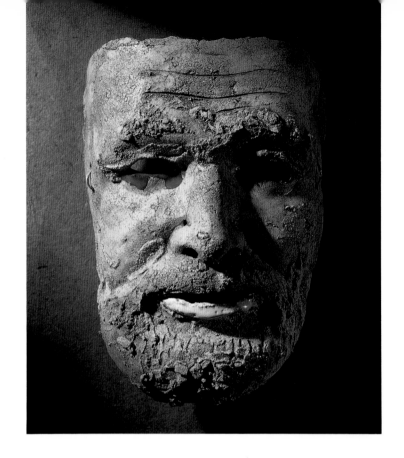

Robert Arneson Λ

A Familiar Face, 1992
signed and dated on verso
glazed ceramic
10 x 7 x 4½ inches
Collection of Carol and Saul Rosenzweig

Masami Teraoka ➤

Rick, 1992
signed, titled and dated on verso and inscribed,
 "lymphoma caused by AIDS" and "I went to
 see a cemetery and found a nice place to rest"
Plaster, wax, wire and needles
17 x 11 x 6½ inches
Collection of Ed and Sandy Martin

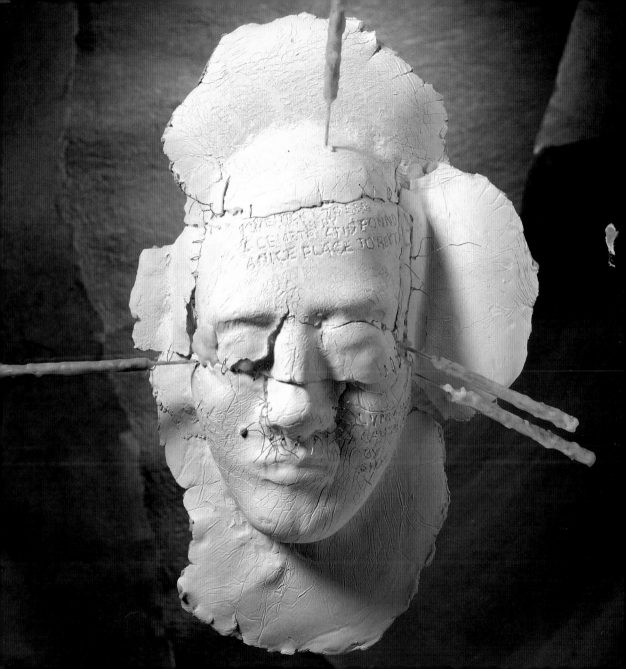

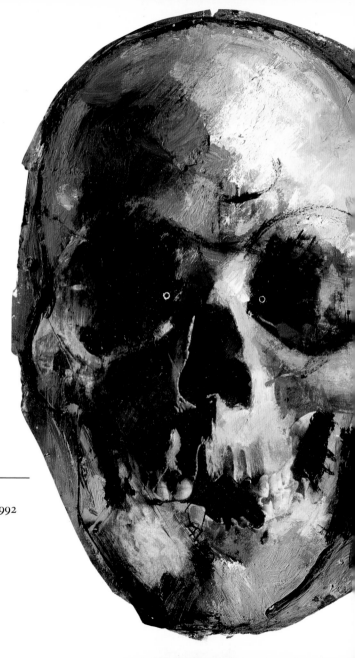

Jim Morphesis

Double Skull Mask (Two Heads Are Better), 1992
signed lower right
oil, enamel, charcoal and collage
 on paper with leather straps
28 x 21¼ inches
Collection of Terri and Michael Smooke

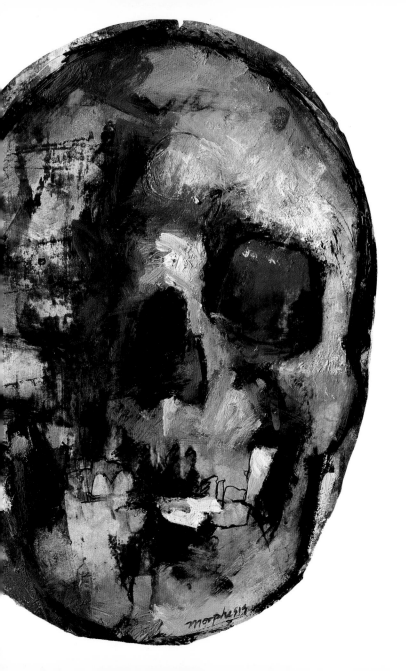

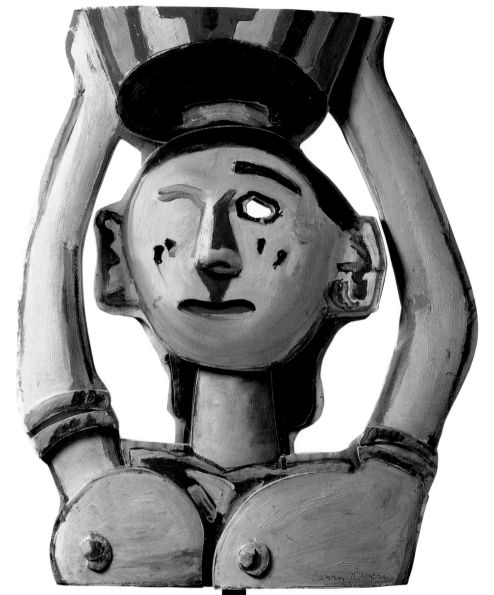

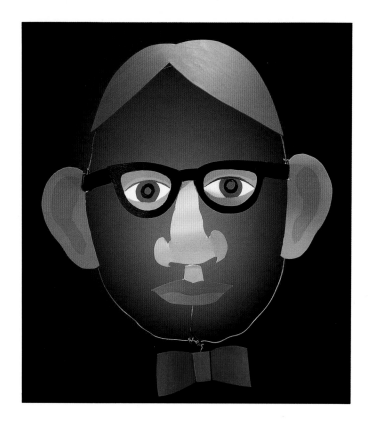

Larry Rivers ◄

Patriotic Mask, Female, 1992
signed lower right
paint on paper mounted on sculpted foamcore
31 x 20 x 2 inches
Collection of Margery Nelson and William Link

Tom Wesselmann ʌ

Mask, 1992
signed and dated on verso
wire and painted paper cutout
approximately 12 x 10 x 4½ inches
Collection of Neal Krone

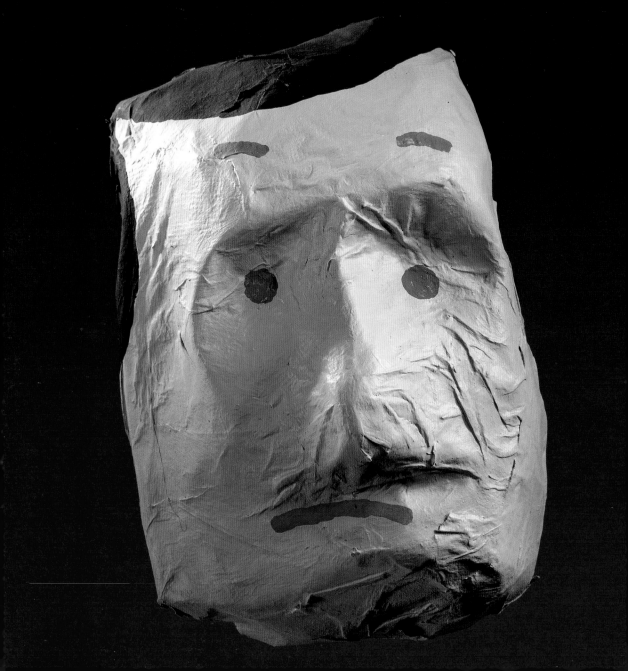

Donald Baechler ≺

Mask, 1992
signed, titled and dated
painted papier mâché
10⅓ x 7 x 4½ inches
Collection of Linda and Jerry Janger

D.J. Hall ≻

All That Glitters, 1992
signed, titled and dated on verso
papier mâché, tinsel, glitter, ribbon,
 newspaper and photographs
10 x 7½ x 3¾ inches
Collection of Joemy Wilson and Jon Harvey

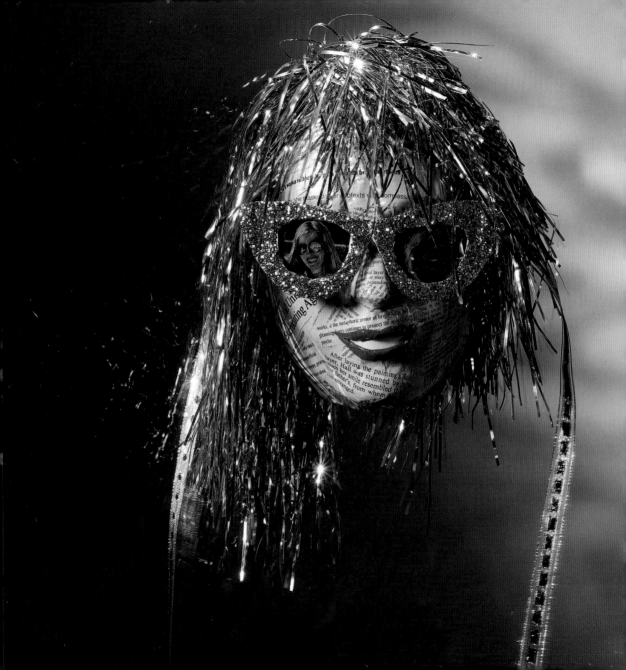

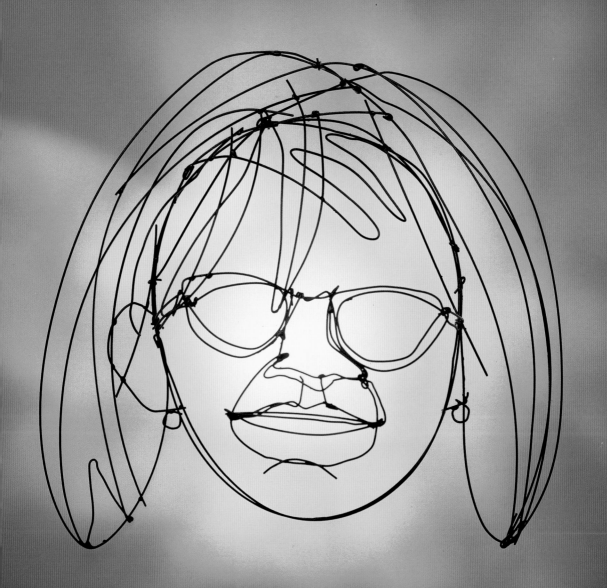

Tom Wesselmann ◄

Alternate Mask, 1992
bent wire
11½ x 12 x 4 inches
Collection of Ron and Nancy Lightstone

Leza Lidow ➤

Medusa, 1992
signed along left edge and signed and
 dated on verso
paint on canvas and mannequin hands,
 mounted on a detachable pole
mask 23¼ x 18 x 2½ inches,
 pole 30½ inches long
Collection of Mrs. Mac L. Sherwood

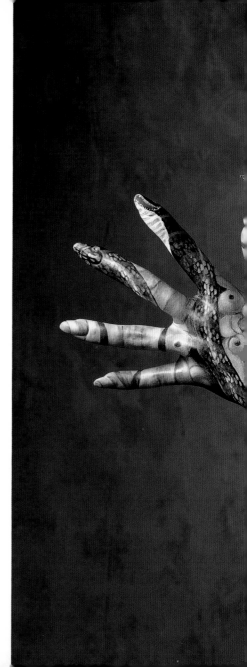

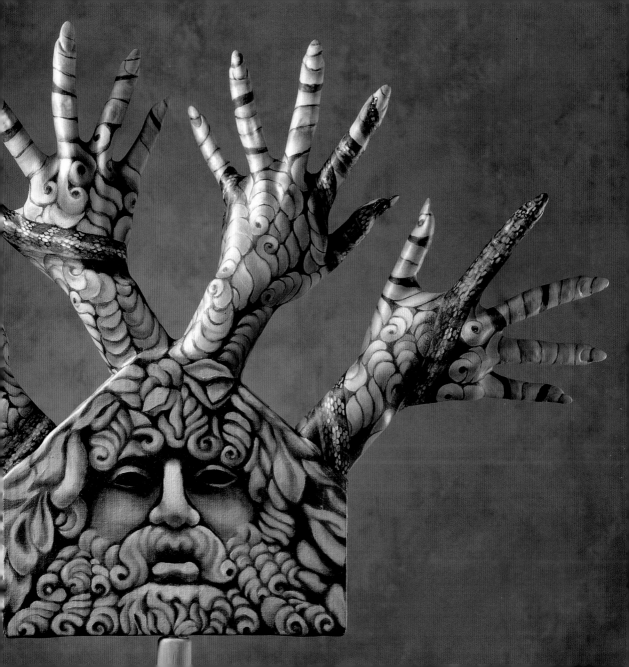

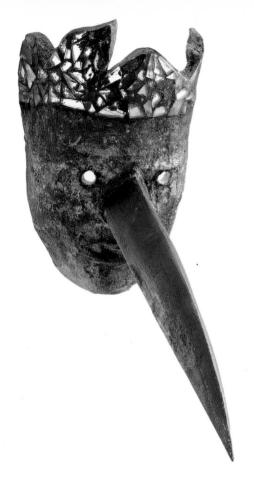

John Alexander ʌ
untitled, 1992
signed and dated
papier mâché, broken mirror, wood and paint
10 x 5 x 13½ inches
Collection of Marshall and Patricia Geller

Jay D. McCafferty ➤
Mask, 1992
signed, titled and dated along left recto edge
two page LACMA letter to the artist with solar
 burns and chalk pastel
11 x 11½ inches
Collection of John H. and Bonnie Wilke

Los Angeles County
Museum of Art

5905 Wilshire Boulevard
Los Angeles, California
90036

Telephone
(213) 857-6021

Telex
(213) 936-5755

March 3, 1992

Jay McCafferty
1017 Beacon Street
San Pedro, CA 90731

Dear Jay,

I am writing to you today in regard to a special event
we are planning for Saturday night, October 31
(Halloween) at the Museum: an auction of artist's masks
to be held in conjunction with our upcoming exhibition,
Parallel Visions: Modern Artists and Outsider Art.

Parallel Visions, which I am co-organizing with
Associate Curator Carol Eliel, will open on October ...
This exhibition will track the inspiration afforded to
modern and contemporary artists, throughout this
century, by the work of "Outsiders" - compulsive,
isolated, visionary, untaught individuals. We will
present paintings and sculptures by forty professional
artists, from Paul Klee and Max Ernst down to the
present day, in juxtaposition with the artistic
achievements of forty Outsiders - the latter being
exhibited in this context for the first time in a major
museum presentation. We hope to make Parallel Visions:
Modern Artists and Outsider Art a scholarly success
that will also find a wide public audience here in Los
Angeles and then in Europe and Japan when the
exhibition circulates next year.

In connection with this exhibition the Museum's Modern
and Contemporary Art Council, the major support group
of the Department, is organizing a gala Outsider
Masked Ball on October 31. This festive event will be
exceptional for the Museum in many ways: in addition
to being a dinner and dance party, it will also be a
costume party and a concert with a special selection of
music selected by Ted Schnabel. The
... will be ... in during the party

The highlight of the evening promises to be the
presentation of specially created artists' masks, made
by friends of the Museum from around the world for this
evening event. These masks can be made by each artist
as he/she sees fit, in any medium or style; they should
measure no more than ... The All work donated
will be on sale by our professional staff ... be on
view until the last part of the evening, when an
auction will take place. All proceeds from the auction
will be used for acquisition of contemporary art for
the Museum.

Would you be kind enough to consider making a mask for
us? I'm certain you may wish to have further
information, and it would be a pleasure for me to
provide you with this, if you would give me a call or
send me a fax.

With warmest wishes and many thanks for your kind
consideration, I am,

Yours, as ever,

Maurice Tuchman
Senior Curator, Twentieth-Century Art

Los Angeles County
Museum of Art

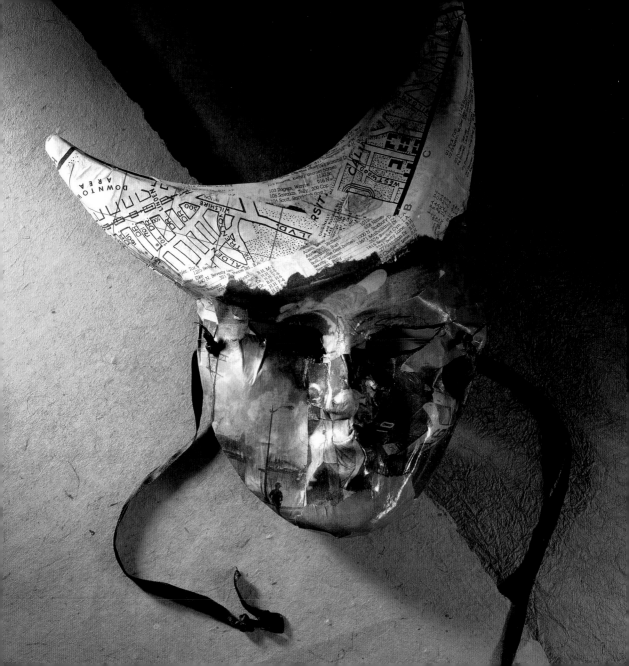

Carol Hayes

L.A. 92, 1992
signed and titled on verso
decoupage and string
12½ x 10 x 1½ inches
Collection of Larry Layne

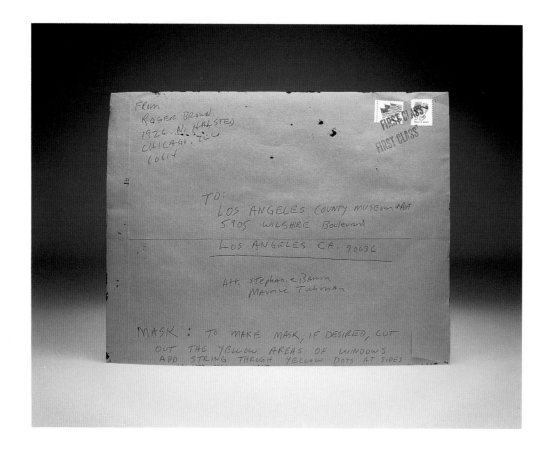

Roger Brown

untitled, 1992
addressed and mailed by the artist to
 LACMA with inscription and stamps
paint on canceled manila envelope
13 x 10 inches
Collection of Daniel L. Kaplan

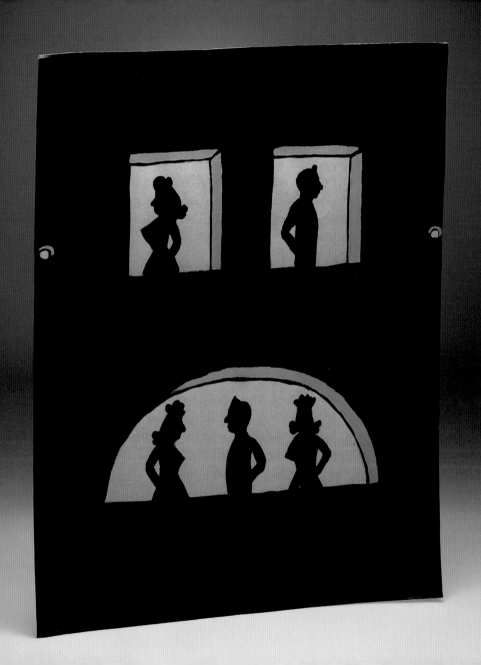

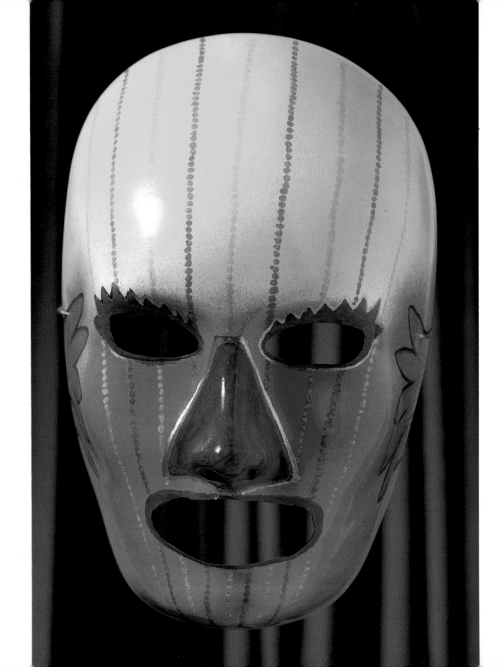

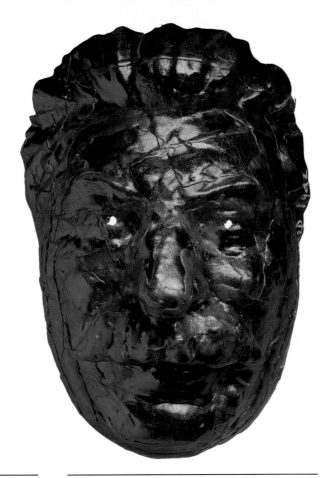

Ed Paschke ◄

untitled, 1992
airbrushed and painted plastic mask
10 x 6 x 4⅓ inches
Collection of Amy A. Weinberg

Vitaly Komar and Alexander Melamid Λ

Red Stalin, 1992
signed and dated along right edge
plastic and red foil
14¾ x 10 x 8 inches
Collection of Dr. Robert and Peggy Sloves

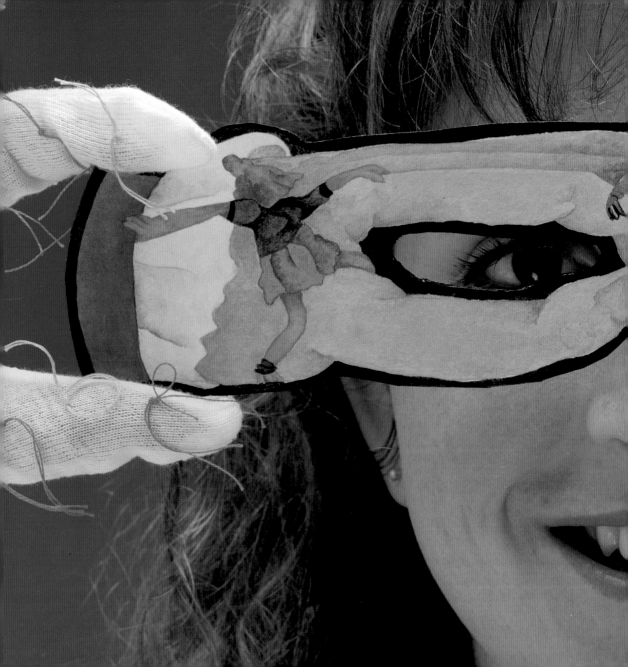

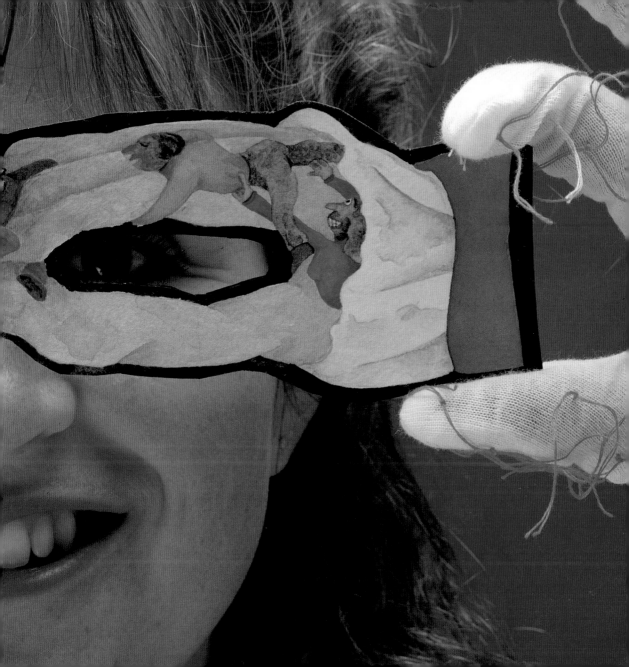

Gladys Nilsson ◄

A Small Disguise, 1992
signed, titled and dated on verso
watercolor on board with cloth "hand masks"
9¾ x 2½ inches
Collection of Rebecca Progrow

Betye Saar ➤

Blue Mask, 1992
signed, dated and titled on verso
found objects and paint on plastic mask
12 x 7 x 3 inches
Collection of Neal Krone

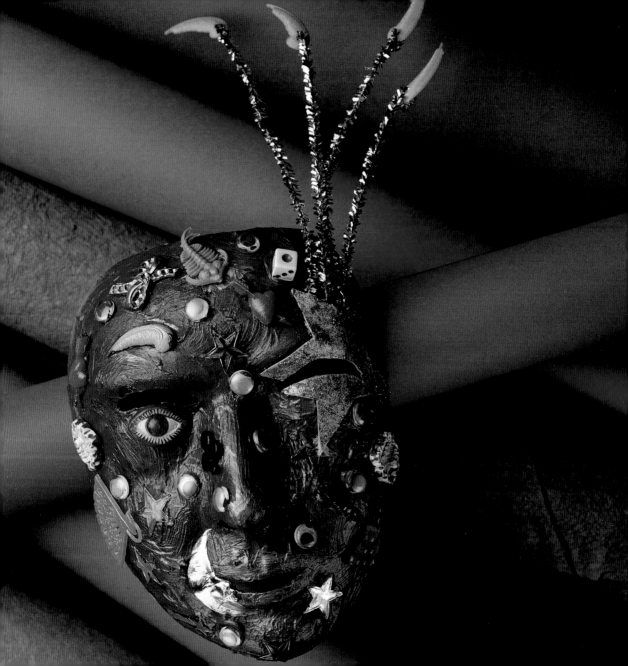

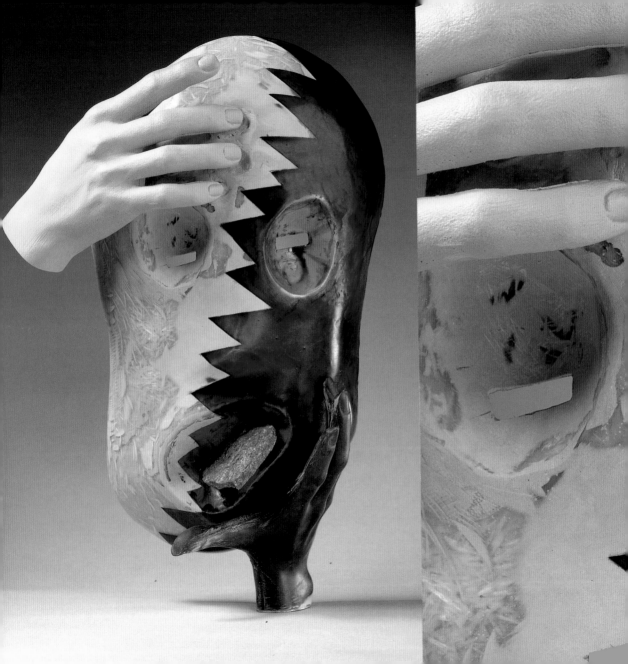

Jud Fine

untitled, 1992
signed and dated on verso
fiberglass construction, mannequin
 hands and stone
21½ x 11 x 5¼ inches
Collection of Drew and Katie Gibson

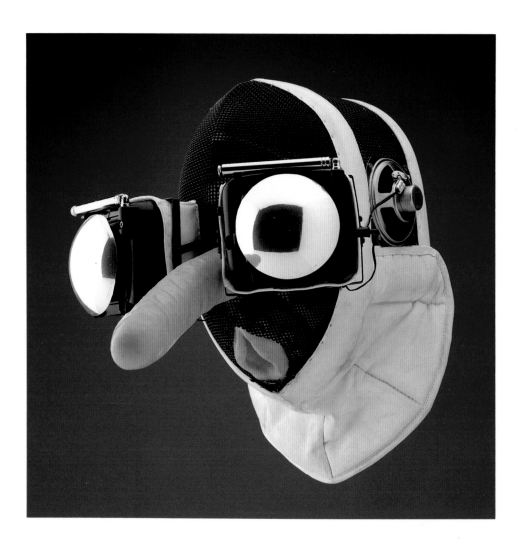

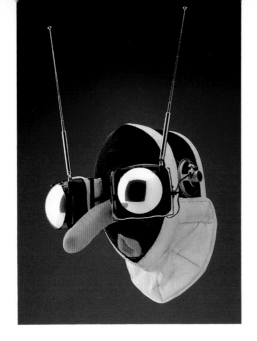

Vito Acconci

Virtual Pleasure Mask, 1992
prototype
fencing helmet, two miniature television
 sets and pink plastic genitalia
approximately 15 x 11 x 16½ inches
Collection of Linda and Jerry Janger

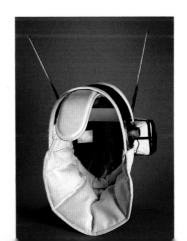

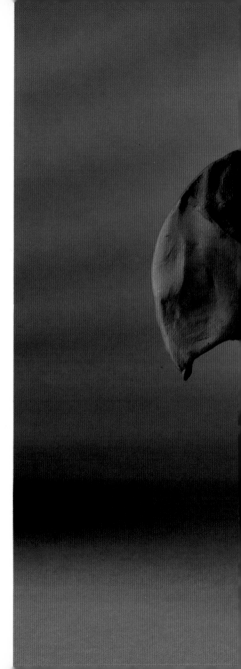

Walter Navratil

And Now for Something Completely Different, 1992
signed and dated on verso
clay
8½ x 10½ x 3⅞ inches
Collection of Francine and Joseph Burg

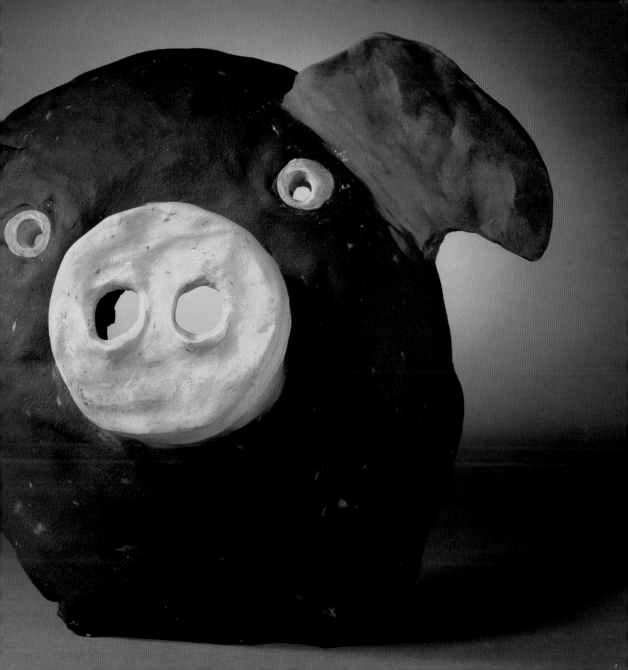

Ilya Kabakov

Myxa, 1992
signed, titled and dated on verso
watercolor and ink on paper with brown string
7½ x 6½ inches
Private collection

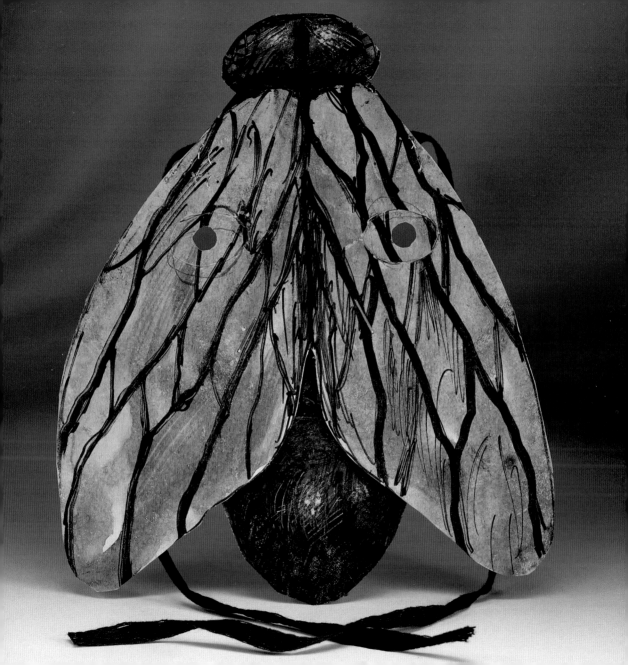

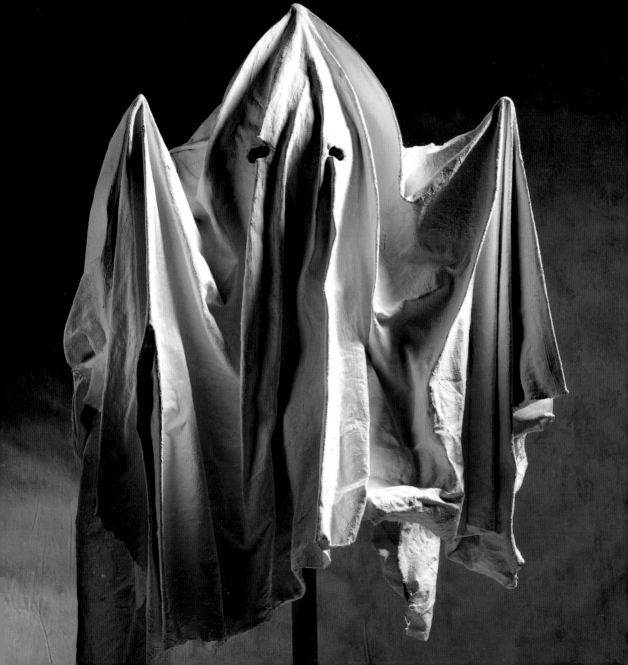

David Salle

untitled, 1992
cloth and plaster on wood stand
37½ x 15⅓ x 15⅓ inches
Collection of Tony and Cindy Canzoneri

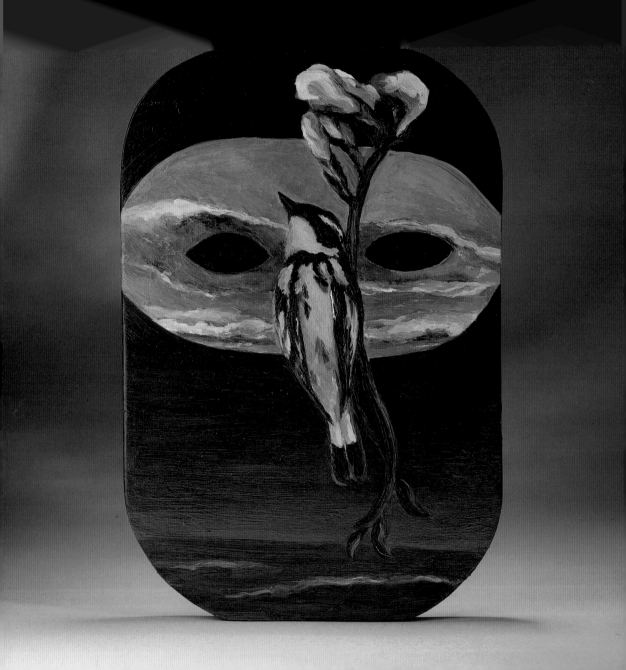

Lindsay McCrum ◄

A Mask for Mr. Magritte, 1992
signed, titled and dated on verso
wood and acrylic
10 x 6¾ x ½ inches
Collection of Suzanne and Tibor Zada

Terry Schoonhoven ►

Circus Peeper, 1992
signed, titled and dated on verso
Mahogany carved wood with enamel paint
18½ x 12½ x 4 inches
Collection of Mrs. Mac L. Sherwood

Gordon Onslow-Ford

Jungle Jag and Jungle Mag, 1992
each signed on verso
painted papier mâché
each 10 x 9 x 3 inches
Collection of Ron and Nancy Lightstone

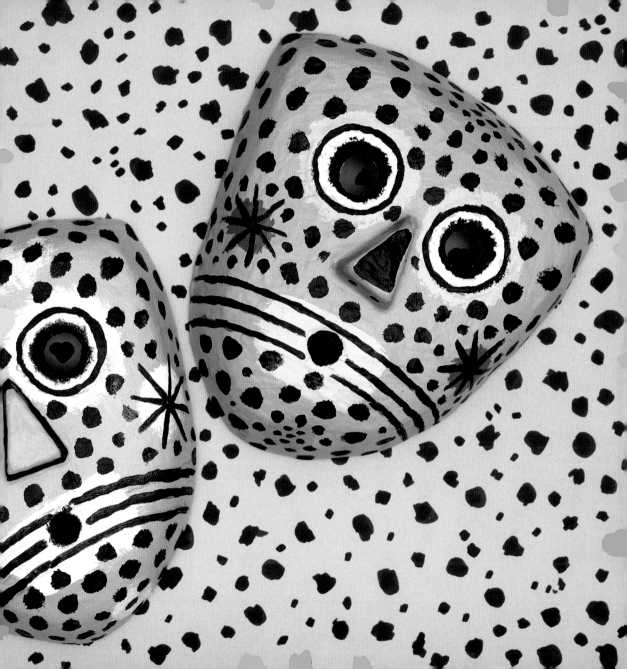

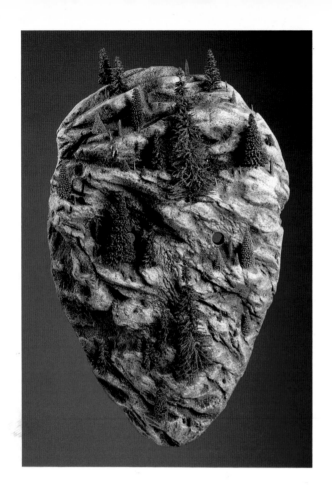

Roland Reiss

Earth Mask, 1992
signed and dated on verso
cement foam, acrylic paint and plastic
18¾ x 12 x 3½ inches
Collection of Mrs. Mac L. Sherwood

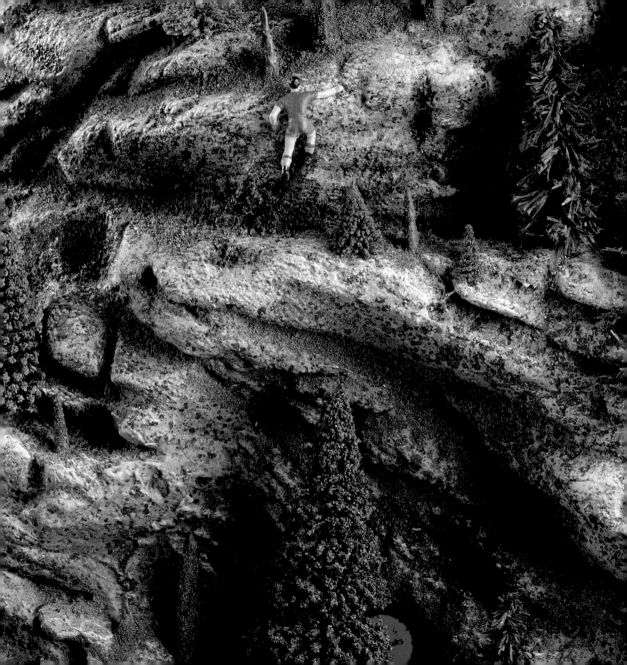

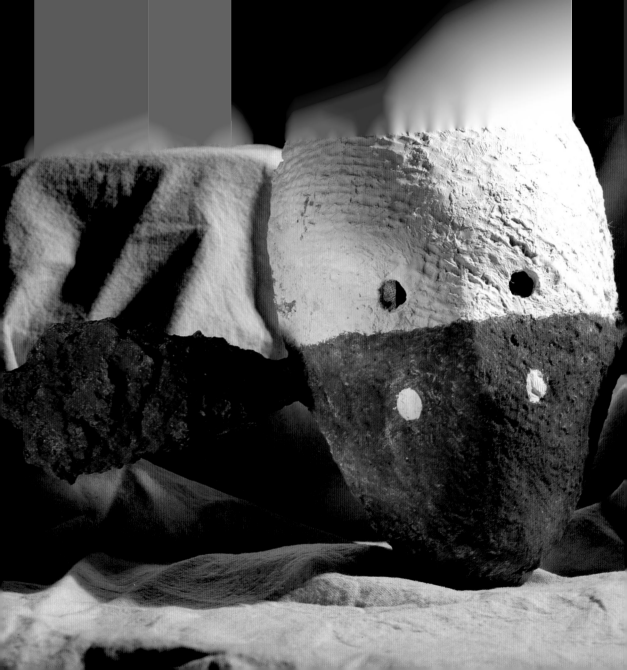

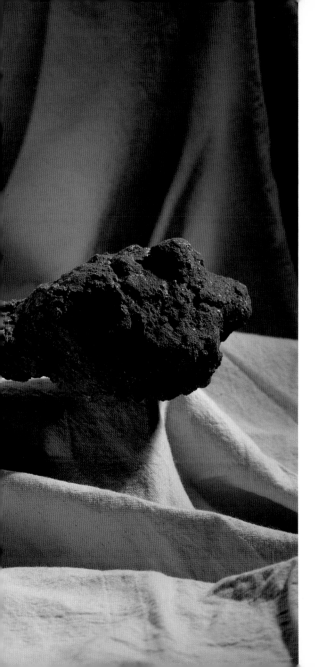

Antony Gormley
A Mask for Feeling the Earth, 1992
initialed, dated and titled on verso
plaster, pigment and fabric
11 x 18½ x 4½ inches
Collection of Linda and Jerry Janger

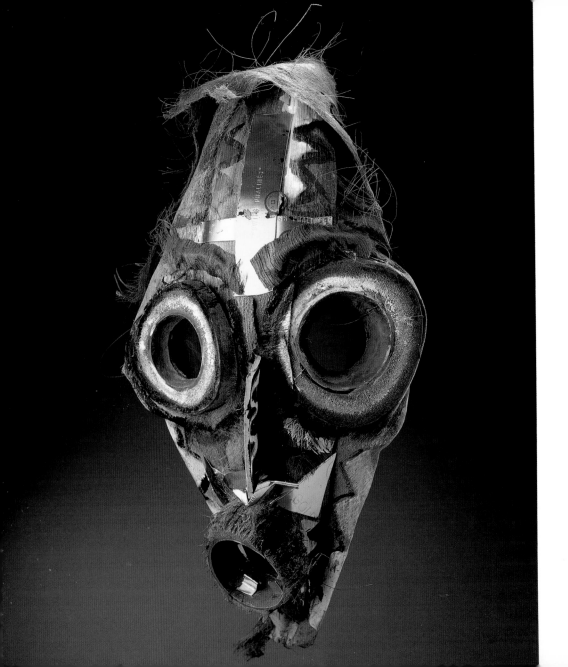

Red Grooms ◄

untitled, 1992
signed and dated on verso
cut coconut shells, palm bark, paint
 and gold-colored paperboard
24 x 13 x 11 inches
Collection of Dr. Robert and Peggy Sloves

James Surls ➤

On Seeing through the Tear, 1992
carved gum wood
42½ x 13½ x 7¼ inches
Collection of Nathan and Beatrice Cooper

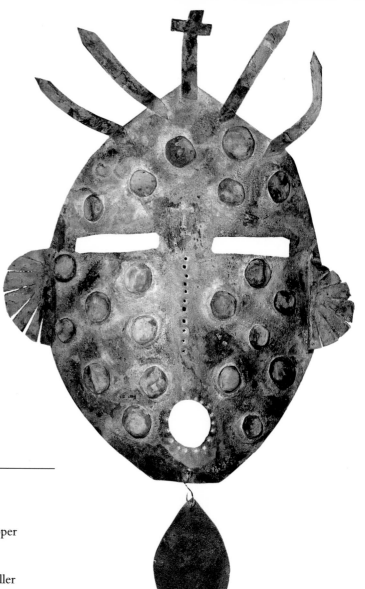

Gregory Amenoff

untitled, 1992
signed and dated on verso
cut and bent copper sheet, applied copper
 elements and green patina
14 x 9 x 1½ inches
Collection of Marshall and Patricia Geller

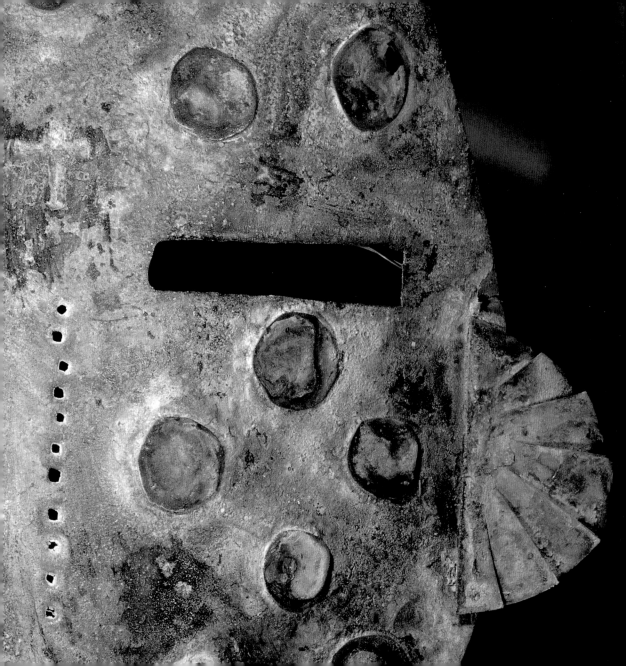

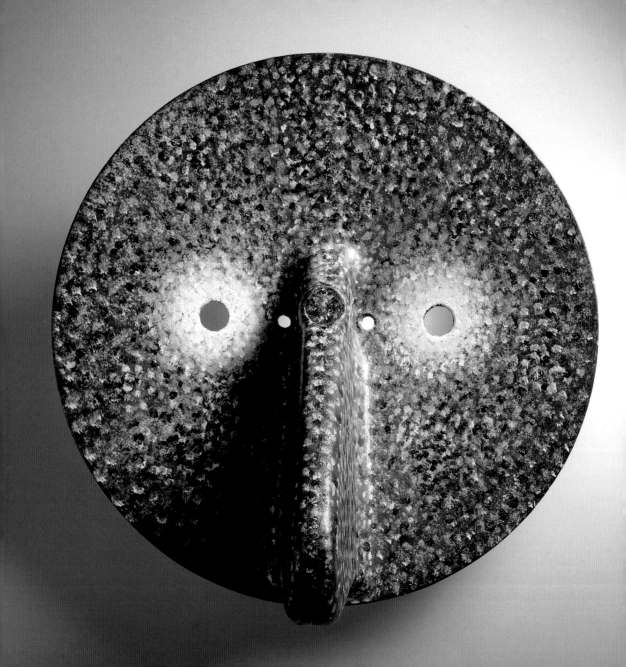

Richard Pousette-Dart

Spirit, 1958
signed, titled and dated on verso
paint on found steel object
diameter: 15¾ inches, depth: 7½ inches
Collection of Terri and Michael Smooke

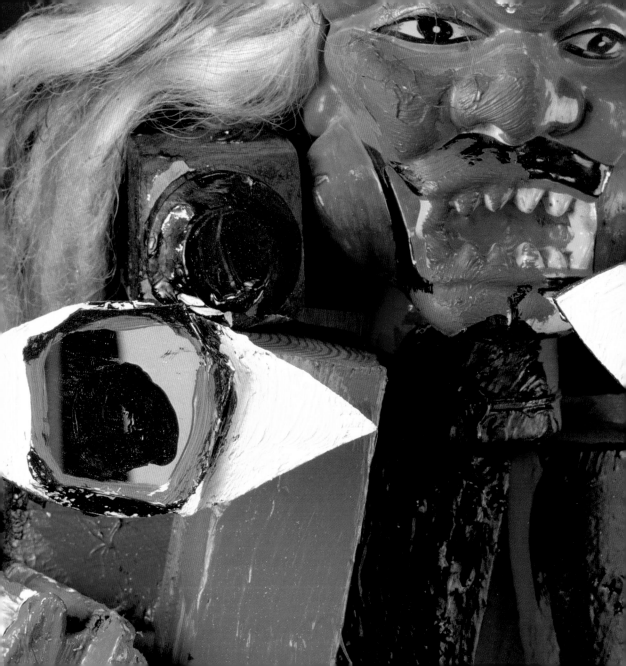

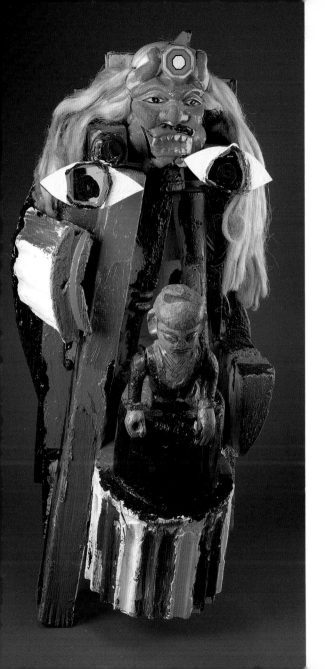

Karel Appel
Mask, 1992
signed and dated on verso
wood, paint and found objects
25½ x 10½ x 15½ inches
Collection of Neal Krone

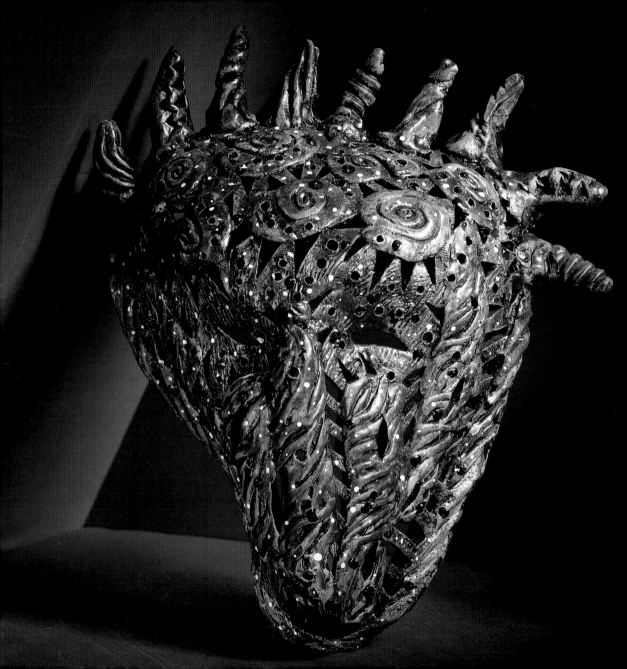

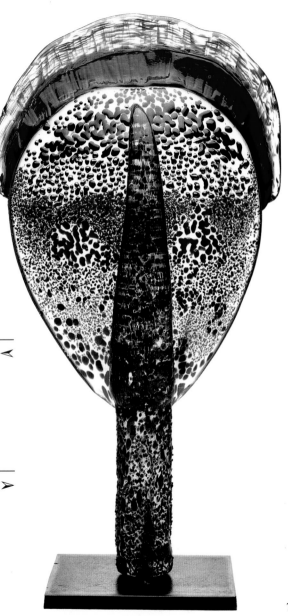

Andy Nasisse ⊲

untitled, 1992
signed on verso
painted ceramic construction
22 x 20 x 8 inches
Collection of Phyllis Wayne

Italo Scanga ⊳

Face and a Landscape, 1992
signed and dated on verso
blown glass with steel base
22 x 12 x 5¾ inches
Collection of Melissa Bordy

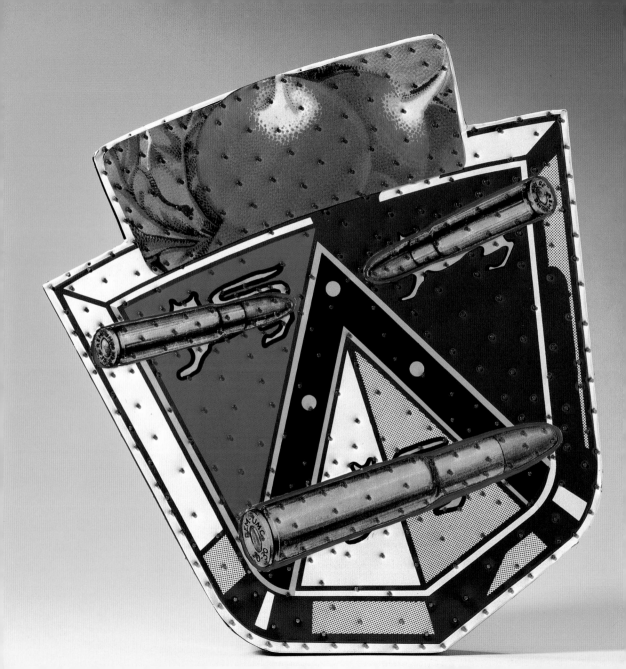

Tony Berlant ≺

LAX, 1992
collage of found tin and nails
11 x 10½ x ¾ inches
Collection of Margery Nelson and William Link

Dan Douke ≻

untitled, 1992
signed, titled and dated on verso
acrylic on foamcore construction
17¼ x 11½ x 3½ inches
Collection of Michael and Vida Goldstein

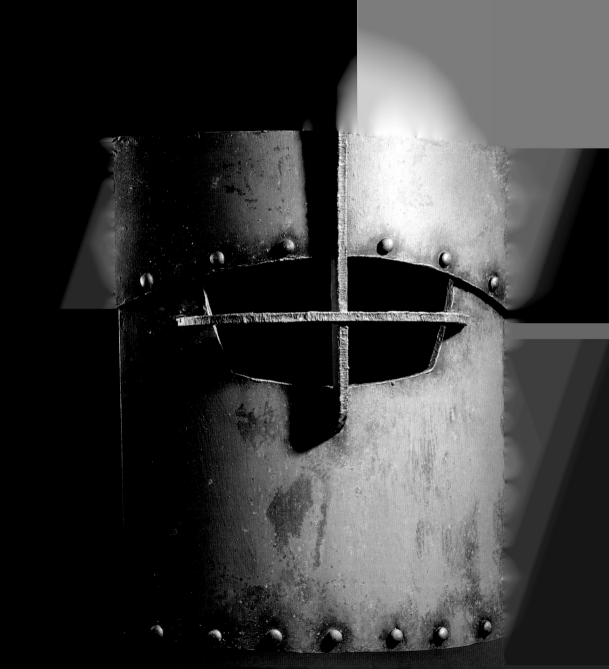

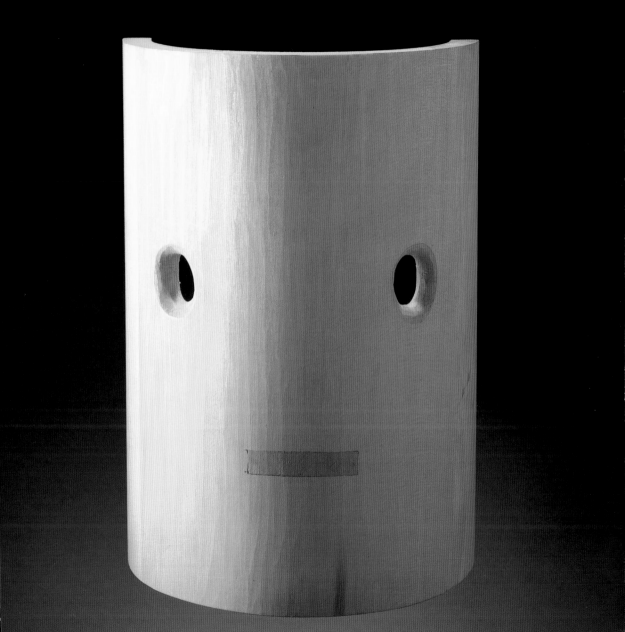

Martin Puryear ≺

untitled, 1992
signed, dated and inscribed on bottom edge
carved and formed wood
10 x 7 x 3¾ inches
Collection of Lee and Lawrence Ramer

Miriam Wosk ➤

Palette Face, 1992
signed and dated on verso
painted wood construction and found objects
 mounted on a wooden painter's palette
24 x 18½ x 8½ inches
Collection of Elinor and Rubin Turner

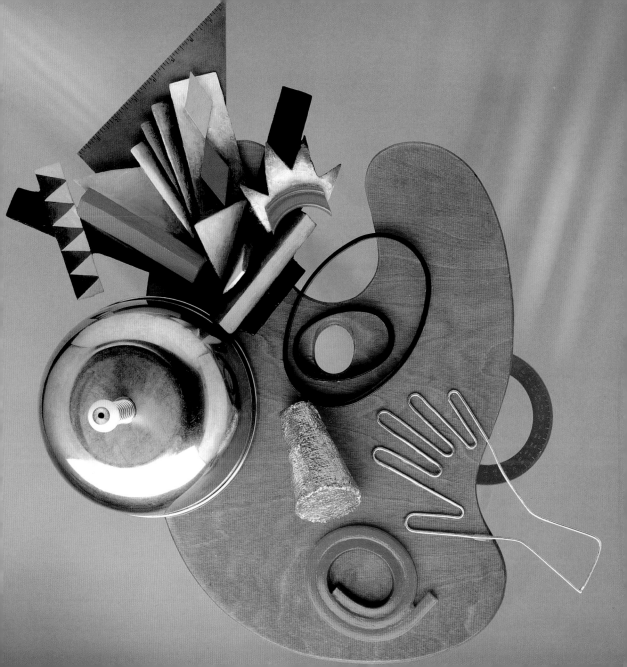

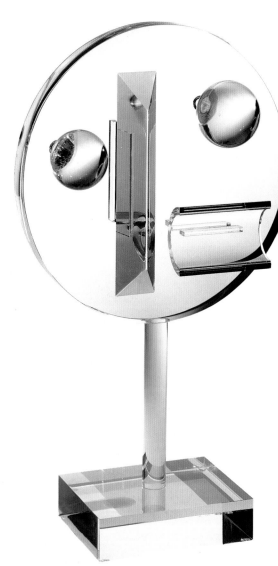

William Brice ◄
untitled, 1992
Acrylite acrylic construction
15½ x 9 x 4 inches
Collection of Norma and Ralph Wolfstein

William T. Wiley ►
No Weigh Dude!, 1992
signed, titled, dated and other writing on verso
aluminum, string, wire and engraving
17 x 11 x 2¼ inches
Collection of Jackie Applebaum

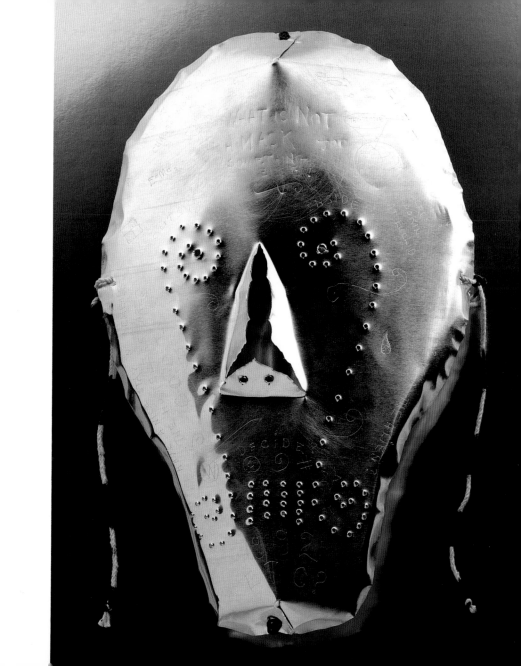

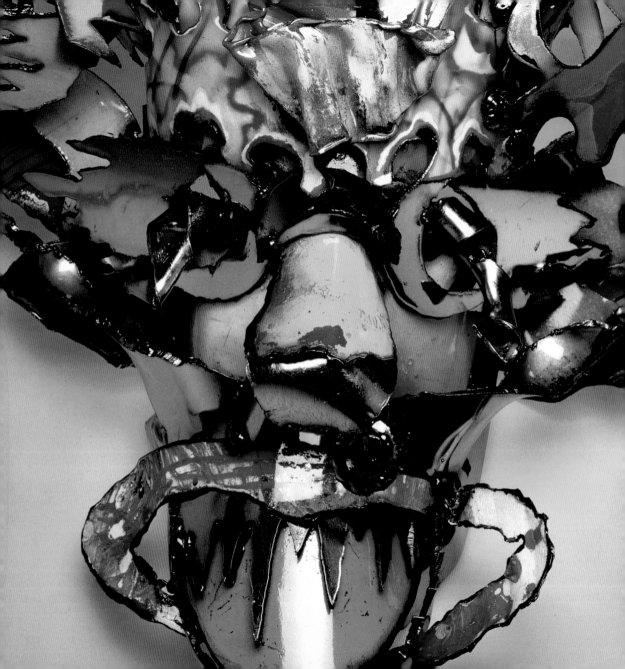

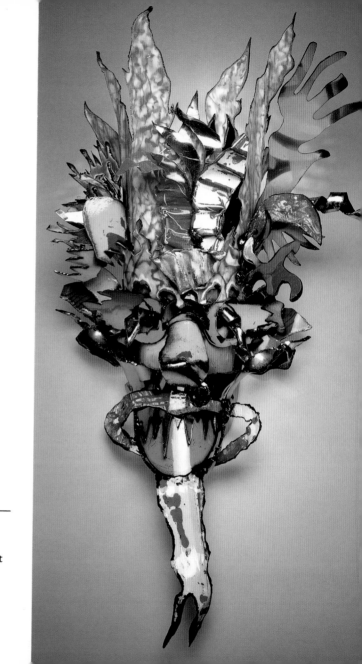

John Chamberlain
Mask O'Salvation, 1992
sheet metal assemblage with autobody paint
approximately 26 x 21½ x 17 inches
Collection of Linda and Jerry Janger

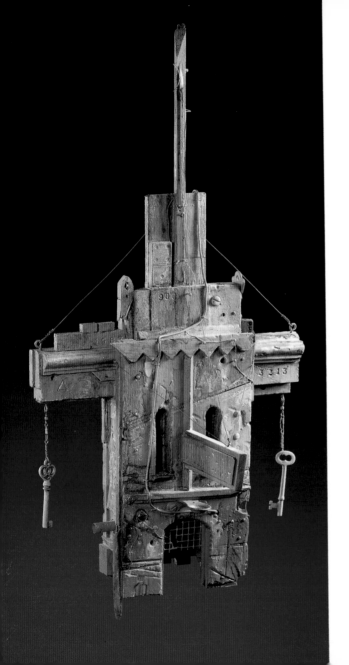

Michael McMillen ◁

The Queen of China, 1992
incised signature and title and artist's
 label on verso
painted wood assemblage with found objects
22½ x 11½ x 8⅓ inches
Collection of John H. and Bonnie Wilke

Arman ▷

untitled, 1992
signed along bottom edge
painted styrofoam, 38 paintbrushes and
 rubber straps
21 x 9½ x 2¼ inches
Collection of Alice and Nahum Lainer

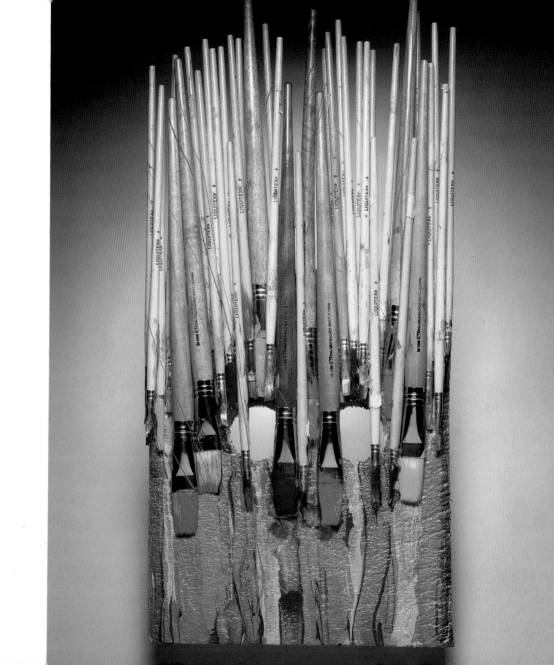

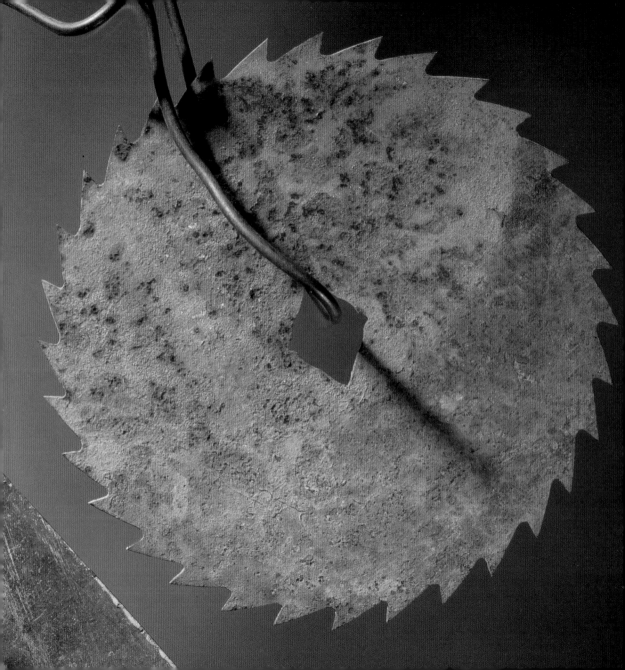

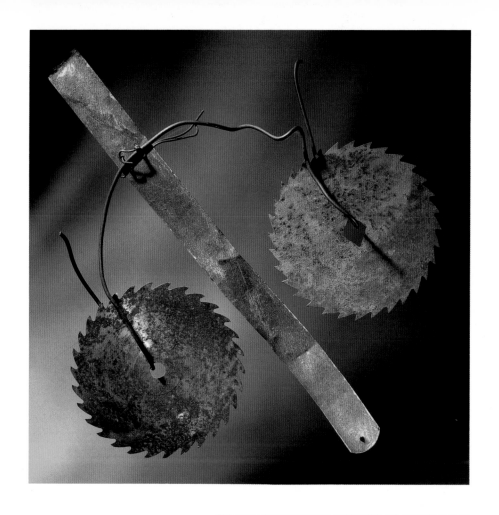

George Herms
untitled, 1992
circular saw blades, wire and metal strip
19½ x 16¾ x 2 inches
Collection of Phyllis Wayne

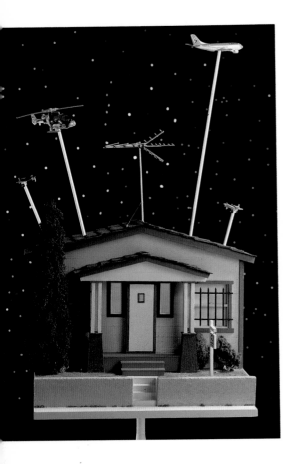

Sandra Mendelsohn Rubin ≺

House Head, 1992
initialed "SMR 92" on miniature for sale sign
wood construction, mixed media and plastic toys
26½ x 13½ x 8¼ inches
Collection of Joemy Wilson and Jon Harvey

Richard Oginz ≻

Pacific Rim Mask, 1992
etched signature and dated on verso
painted carved wood, copper wire and
 carved wood attachments
approximately 20 x 17 x 5½ inches
Collection of Terry and Sheila Schoonhoven

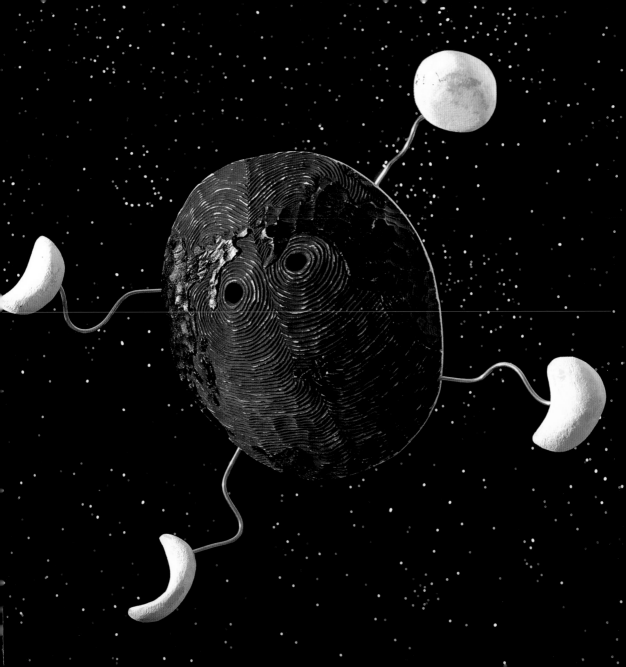

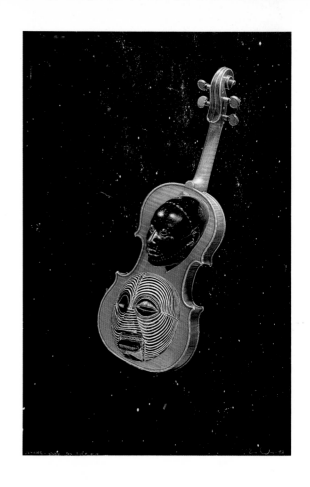

Tom Wudl

Voyager Study for L.A.C.M.A., 1992
signed, dated and titled along bottom recto edge
framed paper collage
21 x 17 x 1¼ inches
Collection of Elinor and Rubin Turner

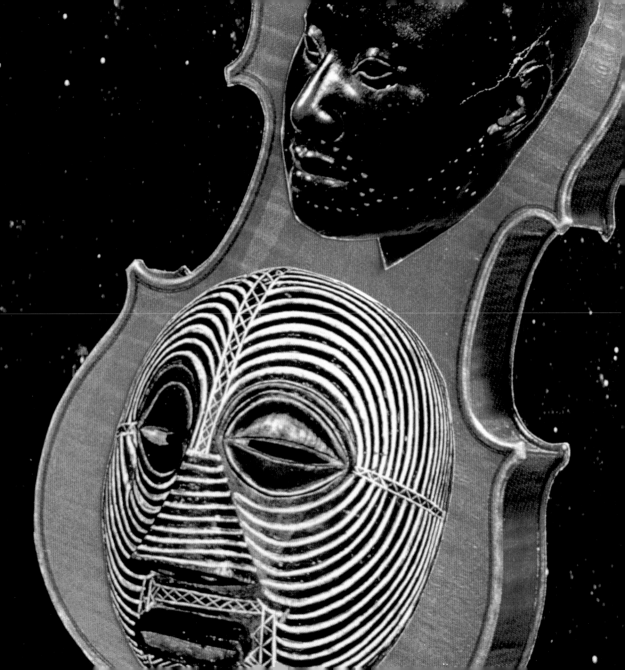

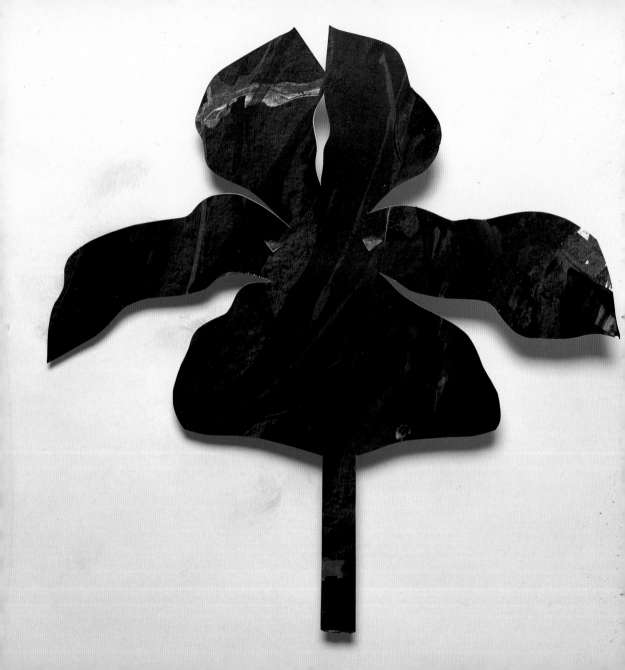

Billy Al Bengston ◄

Mask, 1992
signed, titled and dated on verso
painted cardboard with wood handle
21 x 20¼ inches
Collection of Irving and Evelyn Prell

Laurie Fendrick ➤

untitled, 1992
papier mâché, paint and ear muffs
13 x 12 x 6½ inches
Collection of Larry Lane

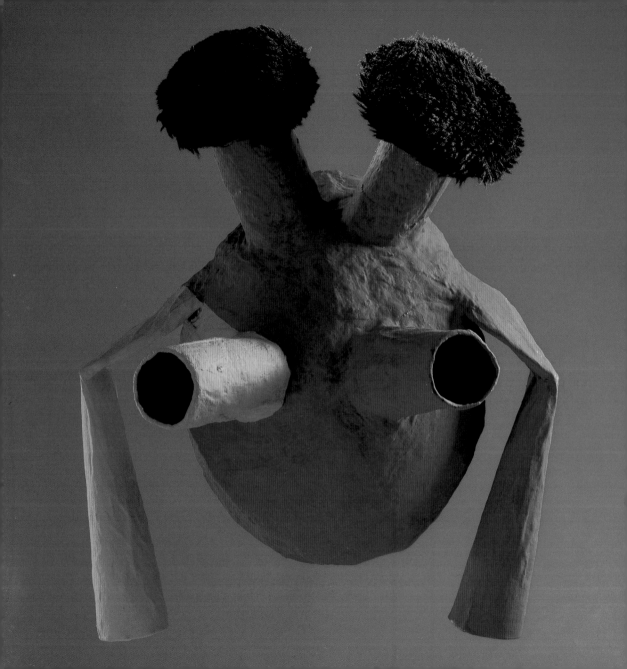

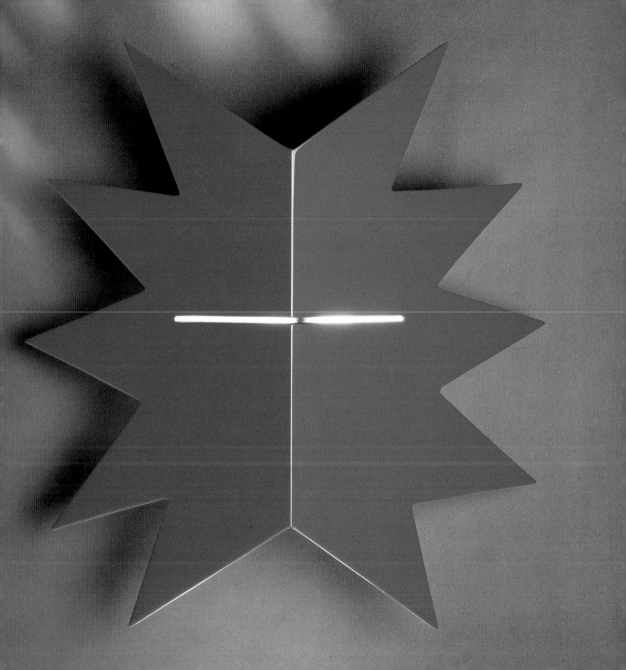

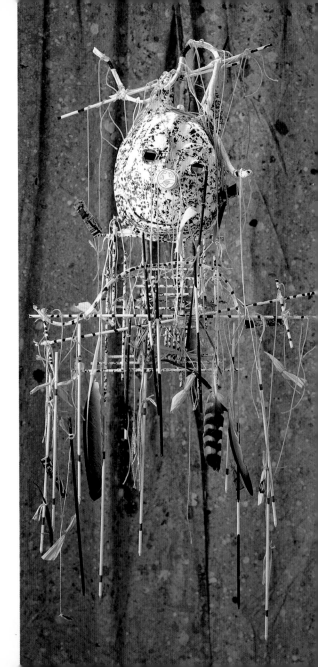

John McCracken ◄

Star Sphinx, 1992
signed, titled and dated on verso
lacquered wood
21¾ x 20¼ x 4⅞ inches
Collection of Alice and Nahum Lainer

Lee Mullican ➤

One, Two, Three, Nose Mask, 1992
papier mâché, painted sticks, string, plastic,
 feathers, paper and natural objects
approximately 39 x 21 x 7 inches
Collection of Patricia Logan

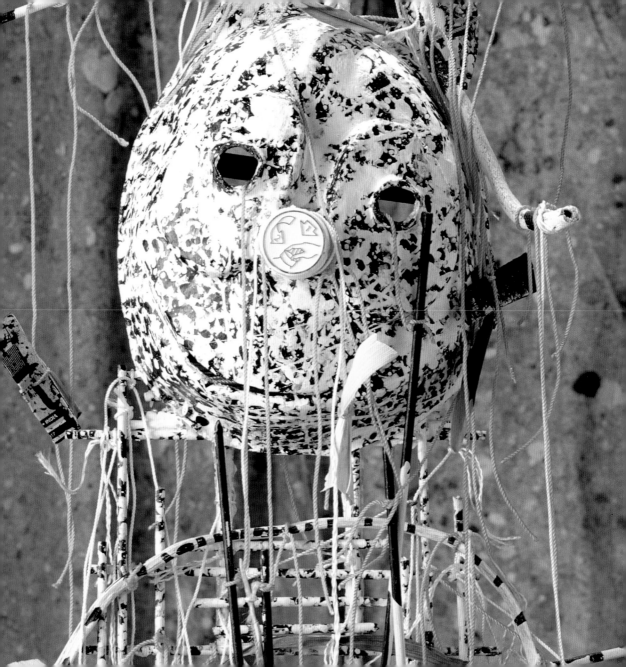

LIST OF PARTICIPATING ARTISTS

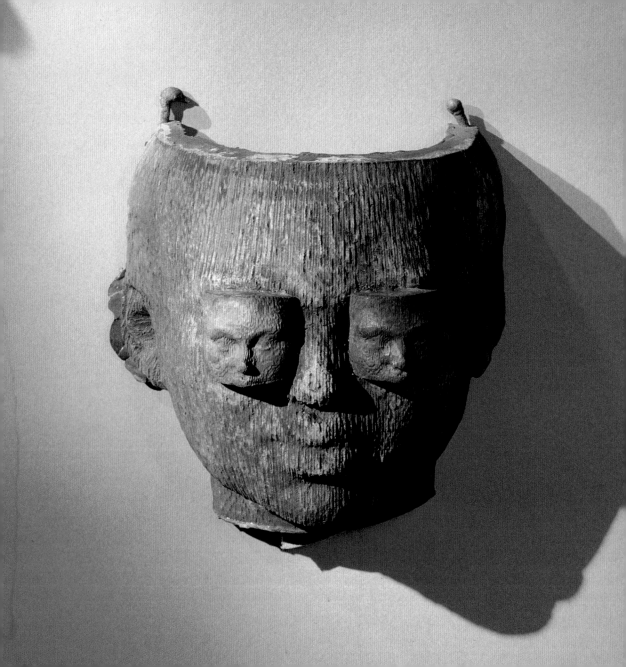

PHOTOGRAPHY CREDITS

The numbers following the photographer's name refer to page numbers.

Peter Brenner: 2–3, 5, 36, 37, 51, 64–65, 85, 88, 89, 95.

Barbara J. Lyter: 17, 41, 44, 45, 47, 59, 62, 70, 72, 73, 79, 91, 102, 103.

Jay K. McNally: 7, 13, 19, 20, 21, 24, 25, 33, 40, 46, 54, 55, 56–57, 78, 80, 86, 87, 98, 100, 101, 106.

Steve Oliver: 6, 9, 10–11, 14–15, 16, 22, 26, 28, 30–31, 32, 34, 38–39, 42, 48–49, 52, 53, 60, 63, 66, 67, 68–69, 71, 74, 76, 77, 82, 83, 90, 92, 93, 94, 96, 97.